SpiritualSeals

expression and introspection

Todd Anthonsen999

BALBOA.
PRESS

A DIVISION OF HAY HOUSE

Balboa Press books may be ordered through booksellers or by contacting:

Balboa Press
A Division of Hay House
1663 Liberty Drive
Bloomington, IN 47403
www.balboapress.com
1 (877) 407-4847

Because of the dynamic nature of the Internet, any web addresses or links contained in this book may have changed since publication and may no longer be valid. The views expressed in this work are solely those of the author and do not necessarily reflect the views of the publisher, and the publisher hereby disclaims any responsibility for them.

The author of this book does not dispense medical advice or prescribe the use of any technique as a form of treatment for physical, emotional, or medical problems without the advice of a physician, either directly or indirectly. The intent of the author is only to offer information of a general nature to help you in your quest for emotional and spiritual well-being. In the event you use any of the information in this book for yourself, which is your constitutional right, the author and the publisher assume no responsibility for your actions.

Any people depicted in stock imagery provided by Thinkstock are models, and such images are being used for illustrative purposes only.
Certain stock imagery © Thinkstock.

ISBN: 978-1-5043-5361-8 (sc)
ISBN: 978-1-5043-5362-5 (e)

Print information available on the last page.

Balboa Press rev. date: 06/07/2016

SpiritualSeals™

Is a simplistic and fun approach to numerology I created as in introduction to this wonderful metaphysical philosophy whose origins stretch back to antiquity and whose application is far reaching and relevant. SpiritualSeals is inspired by the universally recognized designs of the zodiac, and my vision to apply a similar approach to numerology.
By adopting a similar approach as astrology, one can identify and share how their Purpose and Identity are channeled and expressed through the numbers behind their date of arrival and name at arrival.
While the zodiac consists of 12 universally recognized characters, SpiritualSeals consists of 81 mandalas, with each mandala incorporating two elements; that being the number behind the date of birth along with the number behind the full name at arrival.
The number behind the date of arrival reflects ones Purpose, while the number behind the full name reflects their Identity.
Additionally, when the Purpose and Identity are combined, one arrives at the Realization number, which indicates an area of focus upon maturity.

Each pattern surrounding the Seal is designed using the numbers behind the Purpose and Identity.
The Outer design represents the number behind the Life Path/Purpose (Fate) while the inner design represents the number behind the Identity (Destiny).
The numbers behind the Life Path and Identity can be compared to filters in which the lesson and identity is channeled through.
To clarify and distinguish between fate and destiny, FATE (Life Path) can be compared to the road one travels down during life, while DESTINY (Identity) pertains to the extent and nature one goes about traveling down the road of life. FATE pertains to obligation and agreements created prior to incarnation, while DESTINY pertains to options and how one applies free will during incarnation.

In the least complicated terms, Purpose indicates what Life has to offer the individual, while Identity indicates what the individual has to offer life.

Whether the SpiritualSeal you're coloring is your own or a friends, these mandalas promote and provide relaxation as well as reflection. SpiritualSeals can serve as a conversation piece or can remain purely ornamental.
Regardless of how you choose to approach and apply your SpiritualSeal, it is a timeless and meaningful reflection of its owner.

SpiritualSeals™ was inspired by, and compliments my book
Behind the Numbers
for information and insights pertaining to numerology, please visit:

www.btn1111.com

on Facebook:
https://www.facebook.com/btn1111
https://www.facebook.com/signatureart999
https://www.facebook.com/numberlanguage

Your Purpose and Path is channeled through the date of birth.
Your Abilities and Identity are channeled through your full name
Upon maturity, the area of focus and direction of life
is channeled through the reduced sum of the full name and date of birth

SpiritSeals incorporates numerology and geometric designs into a personalized mandala that illustrates the channels one is working through

1	2	3	4	5	6	7	8	9
A	B	C	D	E	F	G	H	I
J	K	L	M	N	O	P	Q	R
S	T	U	V	W	X	Y	Z	

Date of Arrival

full date of arrival reduced to a single digit
i.e. 10-29-1970 -1+0+2+9+1+9+7+0=29/11/2

MONTH	DAY	YEAR
1 0	2 9	1 9 7 0

$\underline{1}+\underline{0} + \underline{2}+\underline{9} + \underline{1}+\underline{9}+\underline{7}+\underline{0} = \underline{29/11/2}$

PURPOSE
(Fate)

②

Name at Arrival

full name at arrival reduced to a single digit

	FIRST	MIDDLE	LAST
name	GEORGE	ALLEN	HANSEN
value	7 5 6 9 7 5 =39	1 3 3 5 5 =17	8 1 5 1 5 5=25

IDENTITY
(Destiny)

⑨

3+9=12/**3** 1+7=**8** 2+5=**7** **3+8+7**=18/9

$$\underline{3} + \underline{8} + \underline{7} = \underline{18/9}$$

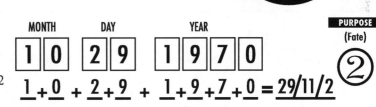

1 - Independence / Initiation 4 - Discipline / Organization 7 - Analysis / Introspection
2 - Intuition / Cooperation 5 - Curiosity / Adaptation 8 - Authority / Determination
3 - Optimism / Imagination 6 - Protection / Obligation 9 - Idealism / Compassion

11 Envisions - Intuitive and Independent 22 Builds - Disciplined and Intuitive 33 Teaches - Affectionate and Creative
0 - Intensifies

Odd Numbers - Masculine - Spontaneous, Initiates/Encourages Expansion Even Numbers - Feminine - Reliable, Maintains/Provides Structure

1	2	3	4	5	6	7	8	9
A	B	C	D	E	F	G	H	I
J	K	L	M	N	O	P	Q	R
S	T	U	V	W	X	Y	Z	

WORKSHEET

Date of Arrival
full date of arrival reduced to a single digit

MONTH DAY YEAR

PURPOSE
(Fate)

_ +_ + _+_ + _+_+_+_ = _____

Name at Arrival
full name at arrival reduced to a single digit

FIRST MIDDLE LAST

name _____

IDENTITY
(Destiny)

value _____

___ + ___ + ___ = ___

Date of Arrival
full date of arrival reduced to a single digit

MONTH DAY YEAR

PURPOSE
(Fate)

_ +_ + _+_ + _+_+_+_ = _____

Name at Arrival
full name at arrival reduced to a single digit

FIRST MIDDLE LAST

name _____

IDENTITY
(Destiny)

value _____

___ + ___ + ___ = ___

1	2	3	4	5	6	7	8	9
A	B	C	D	E	F	G	H	I
J	K	L	M	N	O	P	Q	R
S	T	U	V	W	X	Y	Z	

WORKSHEET

Date of Arrival
full date of arrival reduced to a single digit

MONTH DAY YEAR

PURPOSE
(Fate)

_ +_ + _+_ + _+_+_+_ =_____

Name at Arrival
full name at arrival reduced to a single digit

FIRST MIDDLE LAST

name

IDENTITY
(Destiny)

value

__ + __ + __ = ___

Date of Arrival
full date of arrival reduced to a single digit

MONTH DAY YEAR

PURPOSE
(Fate)

_ +_ + _+_ + _+_+_+_ =_____

Name at Arrival
full name at arrival reduced to a single digit

FIRST MIDDLE LAST

name

IDENTITY
(Destiny)

value

__ + __ + __ = ___

1	2	3	4	5	6	7	8	9
A	B	C	D	E	F	G	H	I
J	K	L	M	N	O	P	Q	R
S	T	U	V	W	X	Y	Z	

WORSHEET

Date of Arrival
full date of arrival reduced to a single digit

MONTH ☐☐ DAY ☐☐ YEAR ☐☐☐☐

_ +_ + _+_ + _+_+_+_ = _____

PURPOSE (Fate) ○

Name at Arrival
full name at arrival reduced to a single digit

FIRST MIDDLE LAST

name _____

value _____

IDENTITY (Destiny) ○

__ + __ + __ = ___

Date of Arrival
full date of arrival reduced to a single digit

MONTH ☐☐ DAY ☐☐ YEAR ☐☐☐☐

_ +_ + _+_ + _+_+_+_ = _____

PURPOSE (Fate) ○

Name at Arrival
full name at arrival reduced to a single digit

FIRST MIDDLE LAST

name _____

value _____

IDENTITY (Destiny) ○

__ + __ + __ = ___

WORKSHEET

1	2	3	4	5	6	7	8	9
A	B	C	D	E	F	G	H	I
J	K	L	M	N	O	P	Q	R
S	T	U	V	W	X	Y	Z	

Date of Arrival
full date of arrival reduced to a single digit

MONTH DAY YEAR

PURPOSE
(Fate)

_ +_ + _+_ + _+_+_+_ =_____

Name at Arrival
full name at arrival reduced to a single digit

FIRST MIDDLE LAST

name

IDENTITY
(Destiny)

value

___ + ___ + ___ = ___

Date of Arrival
full date of arrival reduced to a single digit

MONTH DAY YEAR

PURPOSE
(Fate)

_ +_ + _+_ + _+_+_+_ =_____

Name at Arrival
full name at arrival reduced to a single digit

FIRST MIDDLE LAST

name

IDENTITY
(Destiny)

value

___ + ___ + ___ = ___

Number behind the full date of birth - Purpose/Life Path

1 Purpose—Determination
A purpose channeled through 1 indicates a path consisting of initiative, independence, and individuality. The lesson of 1 involves developing individuality while learning to exercise selflessness/compassion and cooperation.

2 Purpose—Cooperation
A purpose channeled through 2 indicates a path consisting of cooperation, support, diplomacy, and inspiration. The lesson of 2 involves tact and cooperation while learning to develop self-reliance and self-expression.

3 Purpose—Expression
A purpose channeled through 3 indicates a path consisting of creativity, self-expression, and finding humor in life. Challenges along this path pertain to cooperation and discipline.

4 Purpose—Organization
A purpose channeled through 4 indicates a path consisting of creating structure, stability, and security. Challenges along this path pertain to self-expression and adaptation.

5 Purpose—Adaptation
A purpose channeled through 5 indicates a path consisting of exploration, curiosity, and expansion. Challenges along this path pertain to discipline and obligations.

6 Purpose—Obligation
A purpose channeled through 6 indicates a path consisting of responsibility for others and tending to domestic affairs. Challenges along this path pertain to adaptation and introspection.

7 Purpose—Introspection
A purpose channeled through 7 indicates a path consisting of solitude and introspection. Challenges along this path pertain to domestic obligations and management of material assets.

8 Purpose—Acquisition
A purpose channeled through 8 indicates a path consisting of managing personal wealth/resources and exercising authority and judgment. Challenges along this path pertain to introspection and compassion.

9 Purpose—Contribution
A purpose channeled through 9 indicates a path consisting of release and compassion, altruism, and high ideals. Challenges along this path pertain to areas of wealth management and self-identity.

Number behind the full name at birth – Identity/Destiny

1 Identity—Individuality

1 expresses the ability to initiate, stand out, and lead but can easily fall into stubbornness.
Energy channeled through the 1 is competitive, has difficulty seeing the big picture and compromising
as well as participating in endeavors involving teamwork. 1 wants to either take charge or be left alone.
Identities channeled through 1 may have difficulties pertaining to selflessness and cooperation

2 Identity—Cooperation

2 expresses the ability to negotiate and to compromise as well as to inspire. The tendency to avoid
confrontation and self-doubt often makes 2 out to appear weak, when in fact, flexibility is it's greatest asset.
Identities channeled through 2 may have difficulties pertaining to confidence and self-expression.

3 Identity—Creativity

3 expresses the ability toward any creative endeavor and is a natural entertainer who prefers to be in the spotlight.
However, energy being channeled through 3 can express itself through narcissism, drama, and frivolity.
Identities channeled through 3 may have difficulties pertaining to cooperation, discipline and structure.

4 Identity—Organization

4 expresses the ability to organize and expand on existing structures. Dependable and practical, the 4 won't fly
into fits of fantasy, likewise, 4 is rarely spontaneous, and may lack excitement. Identities channeled through 4
may have difficulties pertaining to self-expression and adaptation.

5 Identity—Versatility

5 expresses adaptation and exploration. Individuals expressing themselves through 5 are quick witted, diverse,
adaptive, and outgoing. Identities channeled through 5 may have difficulties pertaining to structure and responsibility

6 Identity—Responsibility

6 expresses the ability to nurture and protect. 6 is patient, caring, perseverant, courageous, embodies
all the virtues of the parent and focuses on domestic issues. Identities channeled through 6 may have
difficulties pertaining to introspection and sudden change.

7 Identity—Analytical

7 expresses the ability to apply introspection, reflection, study and contemplation. Isolated but never removed,
7 is observant and often appears withdrawn. Identities channeled through 7 may have difficulties pertaining
to responsibility and ambition.

8 Identity—Executive ability

8 expresses the ability to apply ambition and values that are essential ingredients in the most common
recipes for personal success. Identities channeled through 8 may have difficulties pertaining to insight
and compassion.

9 Identity—Compassion

9 expresses the ability to extend compassion for humanity and is universal in its outlook.
Energy flowing through 9 gives further appreciation toward all forms of creative expression and humanity
and strives to be all-inclusive in its approach. Identities channeled through 9 may have difficulties
pertaining to obtaining wealth and its management as well as competition. 9 wants to give to all
but rarely remembers to take care of number 1.

Insights on Numerology

- In numerology, rather than indicating quantity, numbers act as 'filters' that channel energy and expresses qualities.

- Numbers found in a chart indicate how one channels their energy, but cannot indicate integrity or ones level of consciousness

- One of the primary objectives of numerology is to provide a general point of reference to encourage personal development through introspection and reflection.

- Numbers provide guidance and insight, but should not be used to define or determine limitations or to create expectations.

- Like notes on a piano, in relationship to each other, alternating keys/numbers express harmony, while consecutive keys/numbers express discord

- Each number consists of lines and arches. The line represents energy projected, and expresses the masculine principle. The arch represents the reception of energy, and expresses the feminine principle. The combination of these two elements represents balance/energy contained
* Additionally, the horizontal line channels from the physical realm, while the vertical line channels from the spiritual realm

1. Initiation Individuality

2. Partnerships Intuition

3. Creativity Optimism

4. Determination Stability

5. Adaptation Curiosity

6. Obligation Loyalty

7. Introspection Analysis

8. Authority Ambition

9. Altruism Release

1	2	3	4	5	6	7	8	9
A	B	C	D	E	F	G	H	I
J	K	L	M	N	O	P	Q	R
S	T	U	V	W	X	Y	Z	

Components of a Numerology Chart

Life Path - Date of Arrival
Direction your Purpose is channeled

Participation - Day of Arrival
Direction from which you interact with the world

Identity - Full Name
Direction of your Inborn abilities

Motivation - Vowels
Motivational force, Nature of your desires

Appearance - Consonants
Appearance to others, Self image

Cornerstone - First Letter
Your approach/point of view

Maturity/Realization
- Path + Identity
Area of focus upon maturity,
often beginning around the 34th year.

Additional Aspects

Aspiration - Name used daily indicates how your inborn abilities are expressed
Inner Self - The number behind the vowels of the name used daily indicates developing ideals and how your Motivation is expressed
Outer Self - The number behind the consonants of the name used daily indicates your conscious impression upon others.

1 **INITIATION** (Mental): Leader, individuality, independent, action-oriented, loner, ambitious aggressive, selfish, pioneering, determined, innovative, stubborn, reliant, daring, opinionated, determined, original, initiative, but not necessarily goal-oriented.

2 **COOPERATION** (Emotional): Gentle, cooperative, balance, supportive, harmony, considerate, sensitivity, intuitive, indecisive, passive, empathic, peaceful, patient, modest, collector, musical, inspirational.

3 **IMAGINATION** (Emotional): Cheerful, enthusiastic, humorous, artistic, optimistic, imaginative, inspired, youthful, easy-going, dramatic, emotional, and idealistic.

4 **DETERMINATION** (Physical): Practical, methodical, organized, determined, perseverance, loyal, disciplined, factual, scientific, serious, ethical, habitual, honest, hard worker.

5 **ADAPTATION** (Physical): Adventurous, witty, adaptable, curious, pleasure loving, energetic, love of freedom, progressive, spontaneous, eccentric, eclectic, expansive, enthusiastic.

6 **OBLIGATION** (Emotional): Family, responsibility, teacher, understanding, nurturing, protective, sociable, love of beauty, romantic, affectionate, concerned, relationship oriented, justice.

7 **INVESTIGATION** (Intuitive): Introspective, loner, analytical, love of nature, philosophical, gatherer of information, stoic, faith, wisdom, spiritual, investigation, skeptical, educated, thinker, discriminating, dignified.

8 **SUPERVISION** (Mental): Authoritative, organized, executive ability, law, righteousness, balance, accomplishment, achievement, accumulation, values, workaholic, prosperity, judgment, goal oriented, materialistic.

9 **COMPASSION** (Intuitive): Compassionate, humanitarian, creative, versatile, idealistic, magnetic, generous, broad outlook, global outlook, caring, responsible, spiritual, forgiving, charitable, impersonality, philanthropic.

13579
ODD
Freedom
Independence
Expression

2468
EVEN
Obligation
Partnerships
Discipline

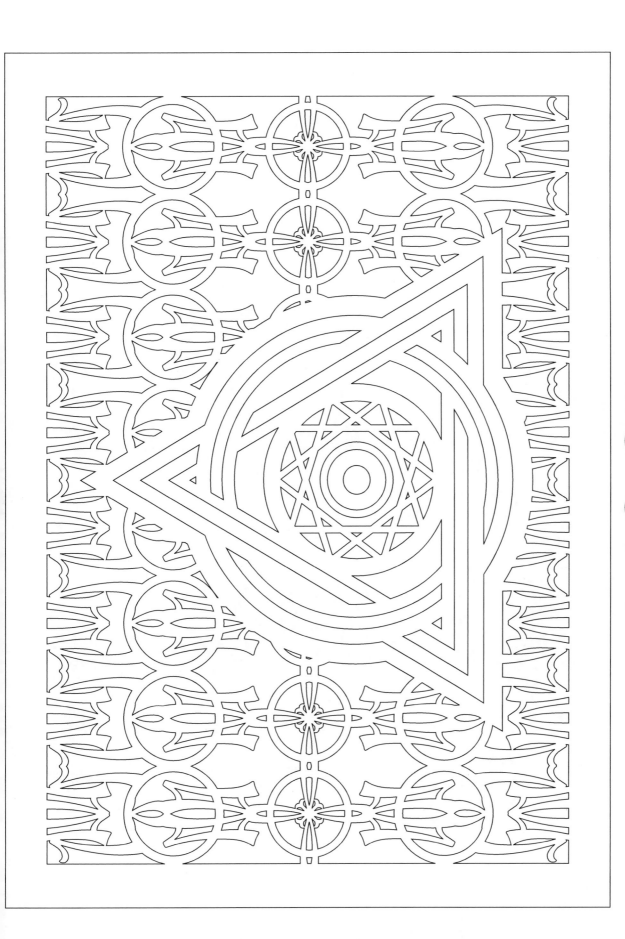

Initiation

Purpose (1) (1) Identity
Fate Destiny

Individuality

Initiation

Purpose ① ② Identity
Fate Destiny

Partnerships

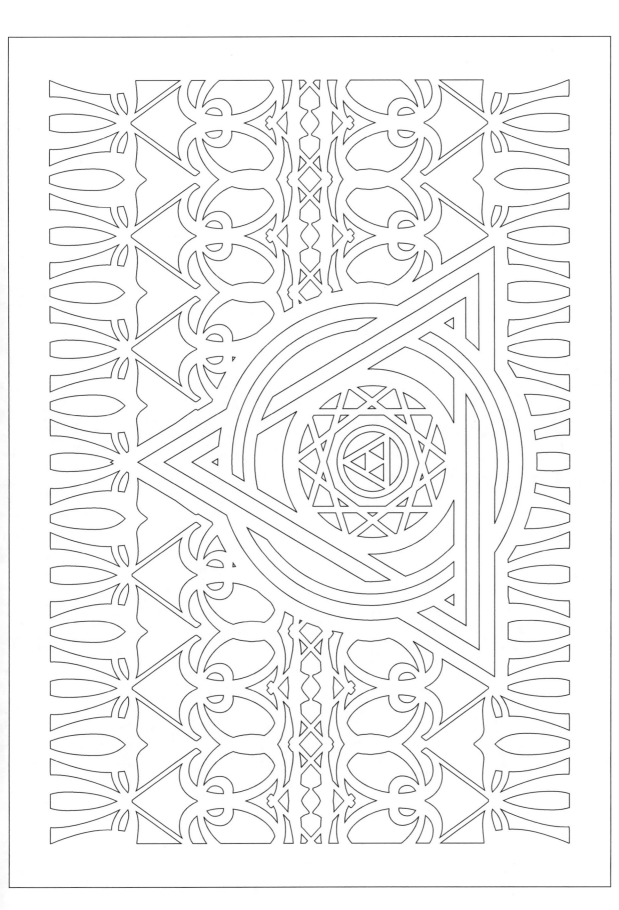

Creativity

Purpose ① ③ Identity
Fate Destiny

Initiation

Stability

Identity
Destiny

Purpose 1 4

Fate

Initiation

Initiation

Purpose 1 5 Identity

Fate Destiny

Adaptation

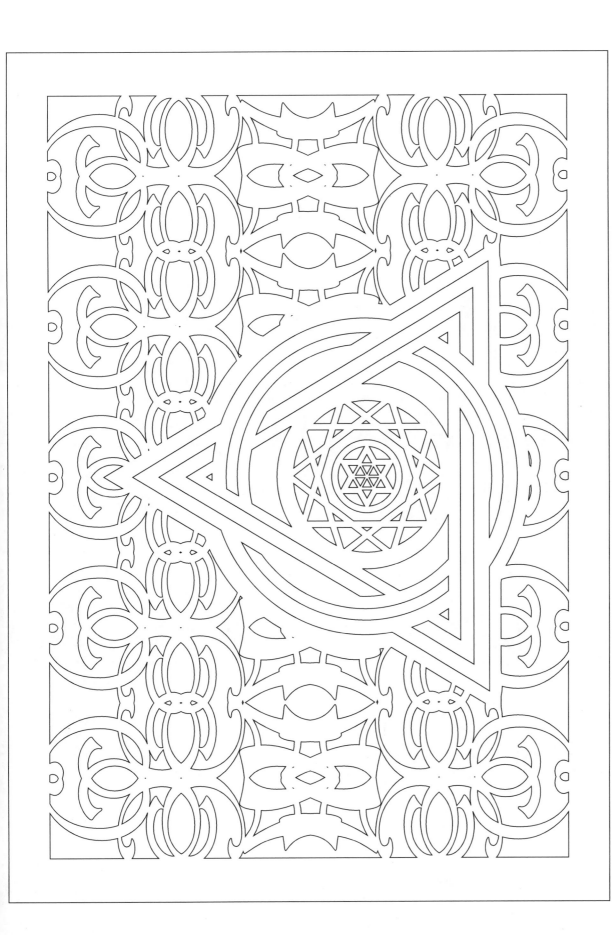

Initiation

Purpose ① ⑥ Identity
Fate Destiny

Obligation

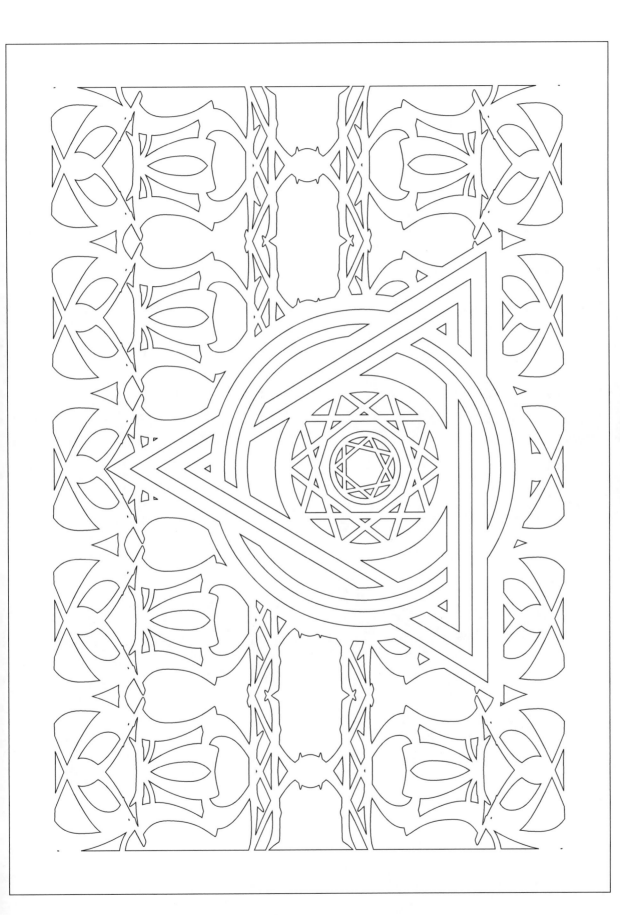

Purpose ① Identity ⑦
Fate Destiny

Analysis

Initiation

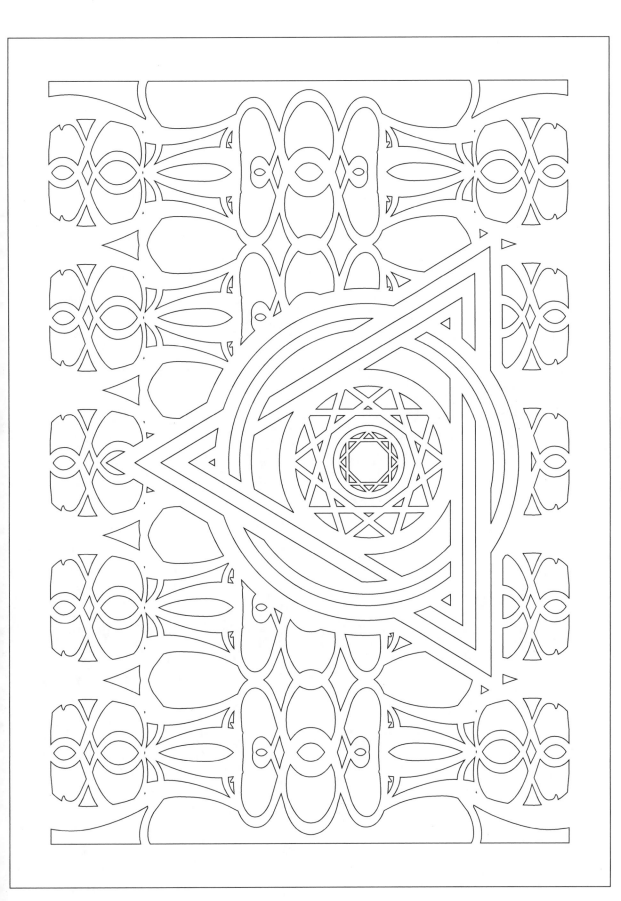

Initiation

Purpose (1)
Fate

(8)
Identity
Destiny

Ambition

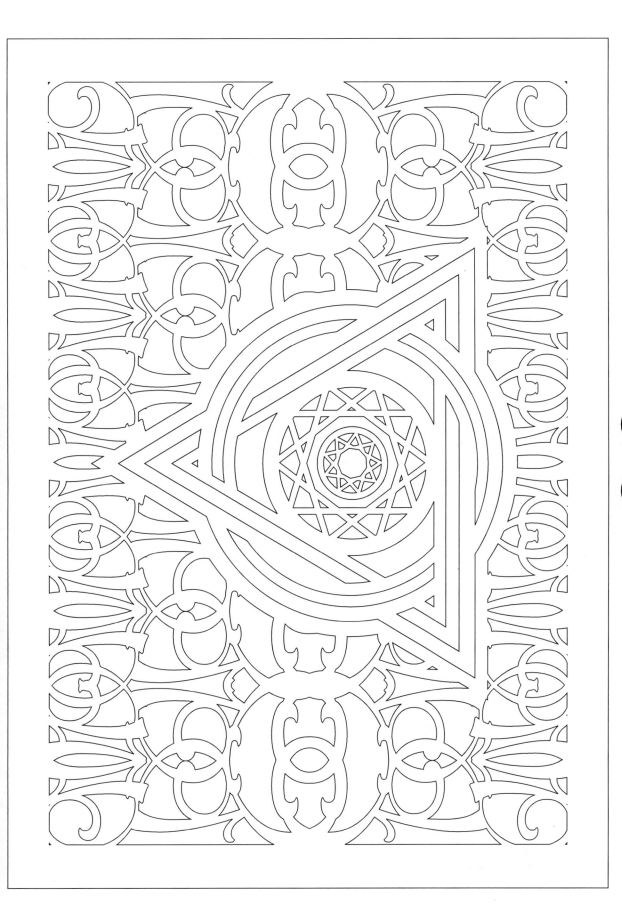

Purpose **1** Identity
Fate **9** Destiny

Altruism

Initiation

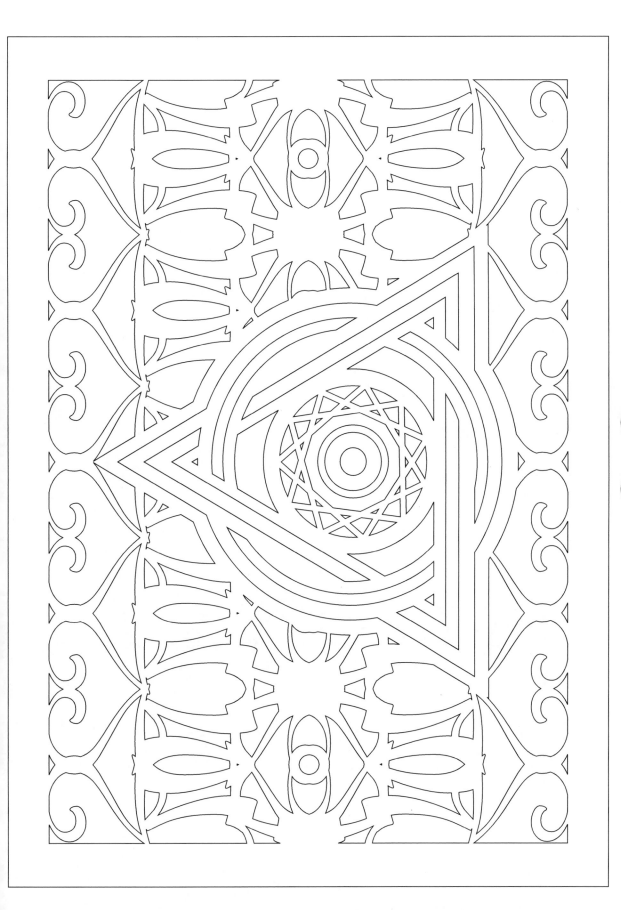

Initiation

Identity
Destiny

Purpose ② ① 1

Partnerships

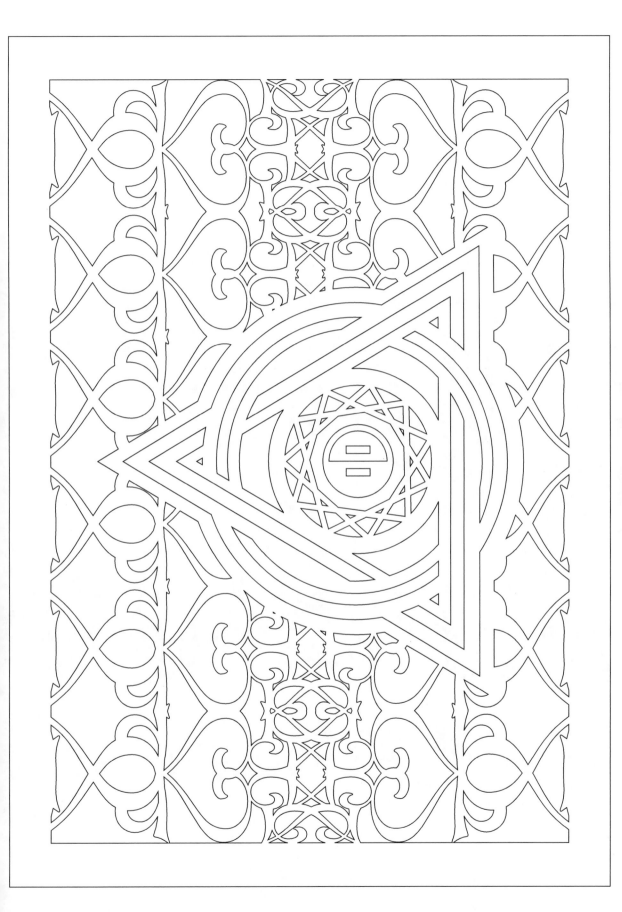

Partnerships

Purpose ② ② Identity
Fate Destiny

Intuition

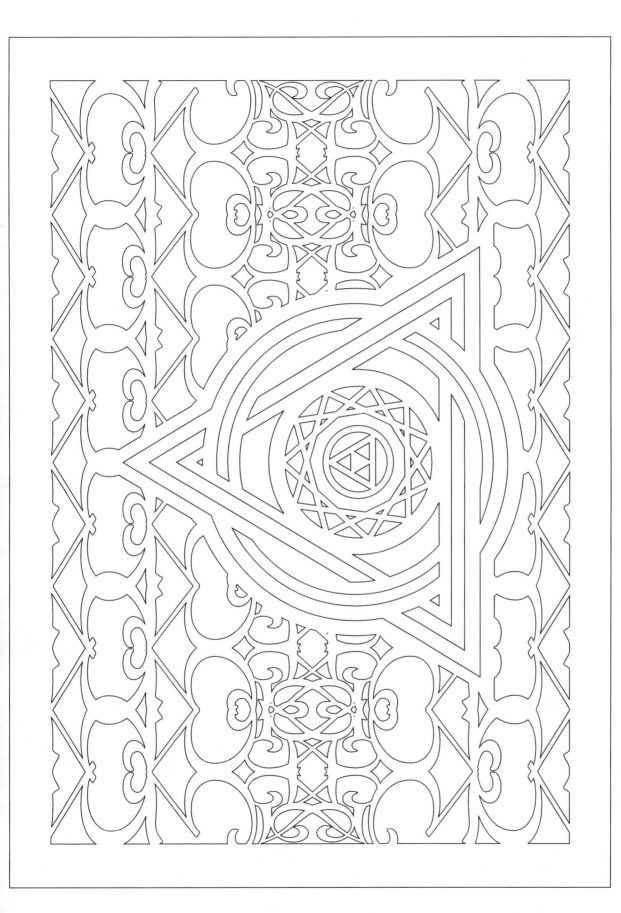

Partnerships

Purpose 2 3 Identity
Fate Destiny

Creativity

Stability

Identity
Destiny

Purpose ② ④

Fate

Partnerships

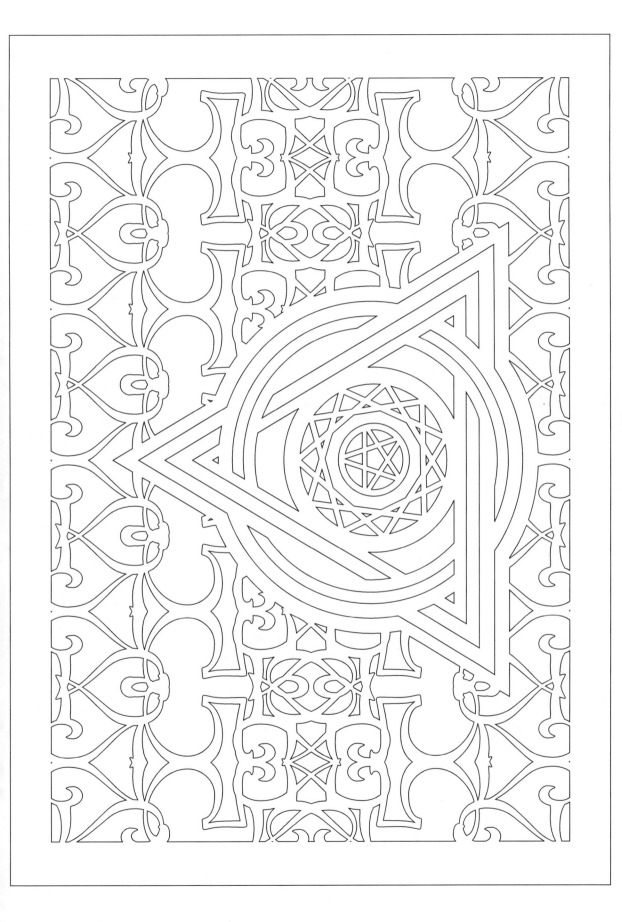

Partnerships

Purpose ② ⑤ Identity
Fate Destiny

Adaptation

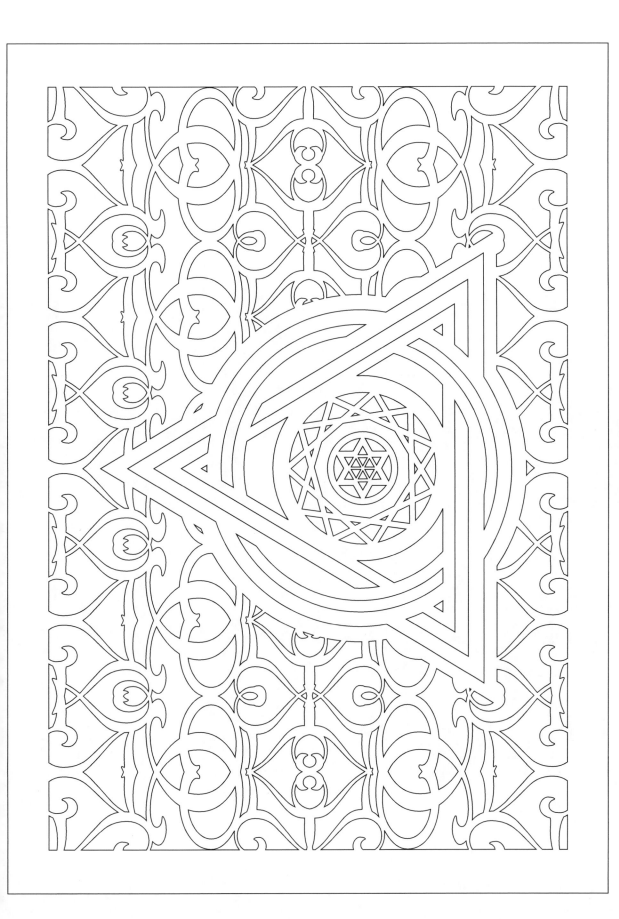

Partnerships

Purpose ② ⑥ Identity
Fate Destiny

Obligation

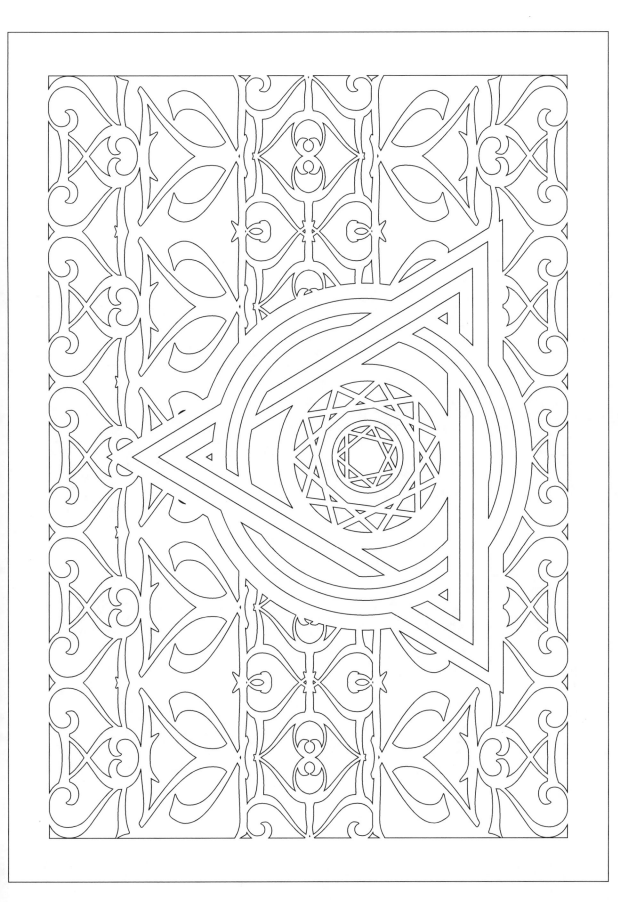

Partnerships

Purpose ② ⑦ Identity
Fate Destiny

Analysis

Partnerships

Ambition

Purpose ② ⑧ Identity
Fate Destiny

Partnerships

Purpose ② ⑨ Identity
Fate Destiny

Altruism

Creativity

Purpose ③
Fate

Identity ①
Destiny

Initiation

Creativity

Purpose ③ ② Identity
Fate Destiny

Partnerships

Creativity

Purpose ③ ③ Identity
Fate Destiny

Optimism

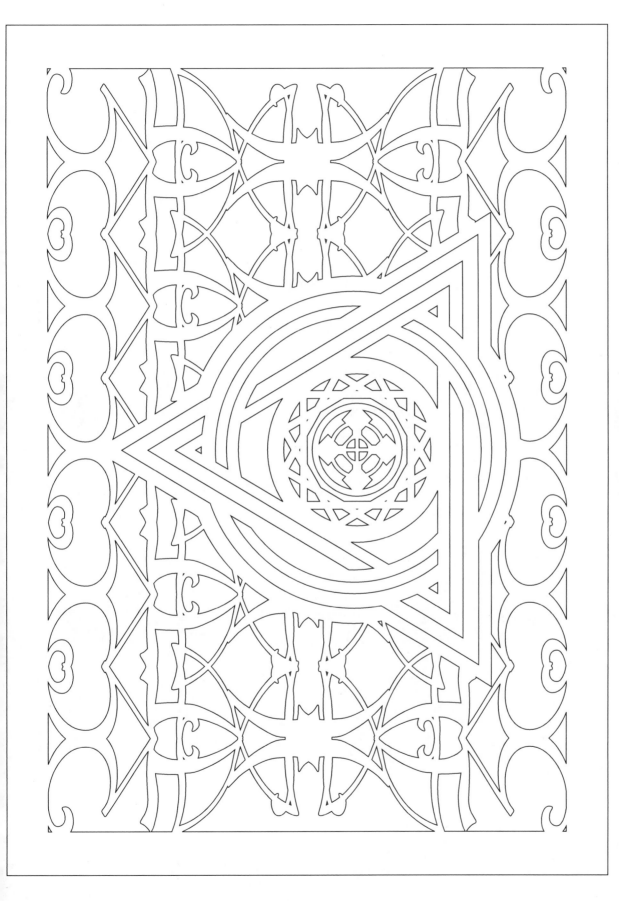

Stability

Creativity

Purpose ③ ④ Identity
Fate Destiny

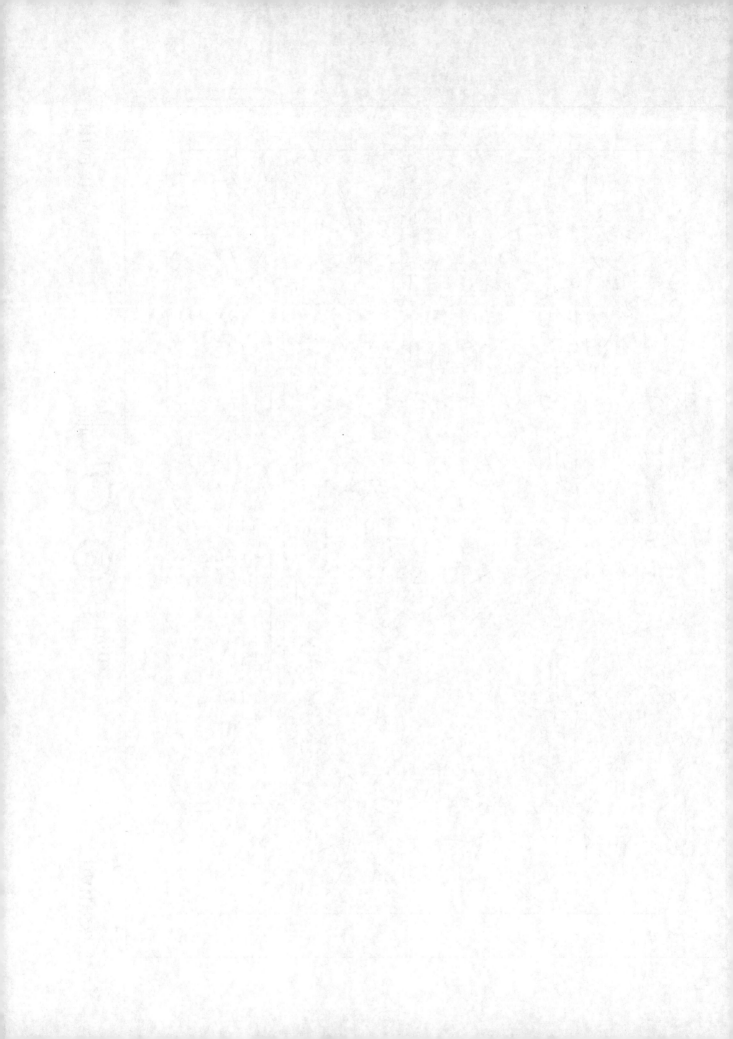

Creativity

Purpose ③ ⑤ Identity
Fate Destiny

Adaptation

Creativity

Purpose ③ ⑥ Identity
Fate Destiny

Obligation

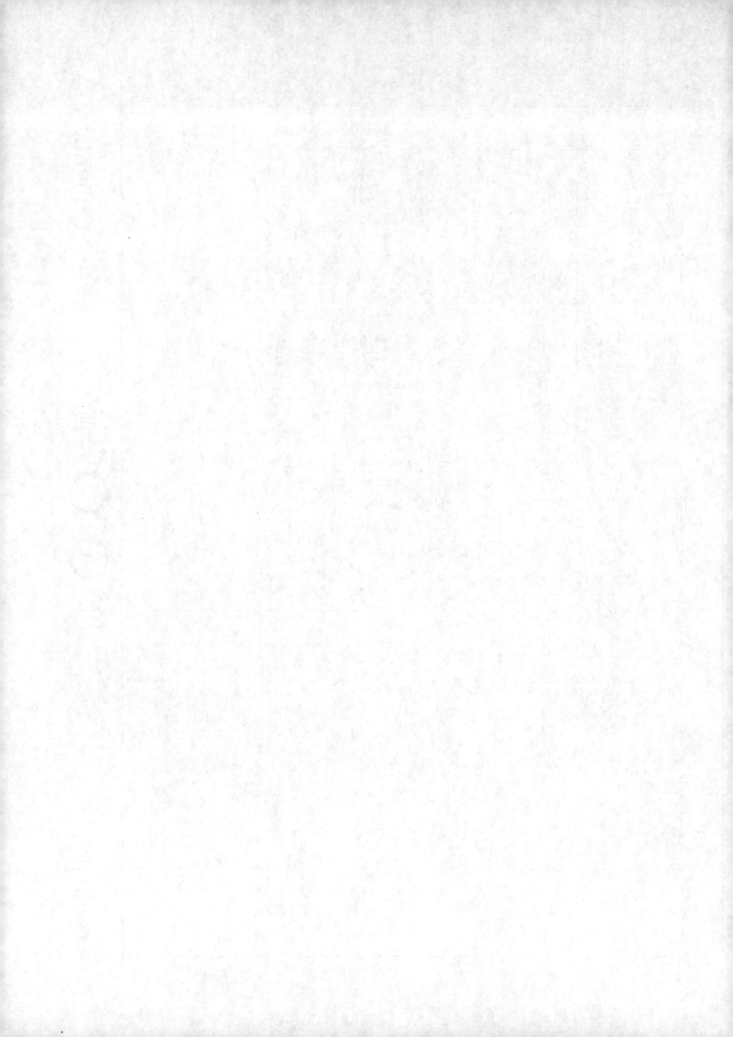

Creativity

Purpose ③ ⑦ Identity
Fate Destiny

Analysis

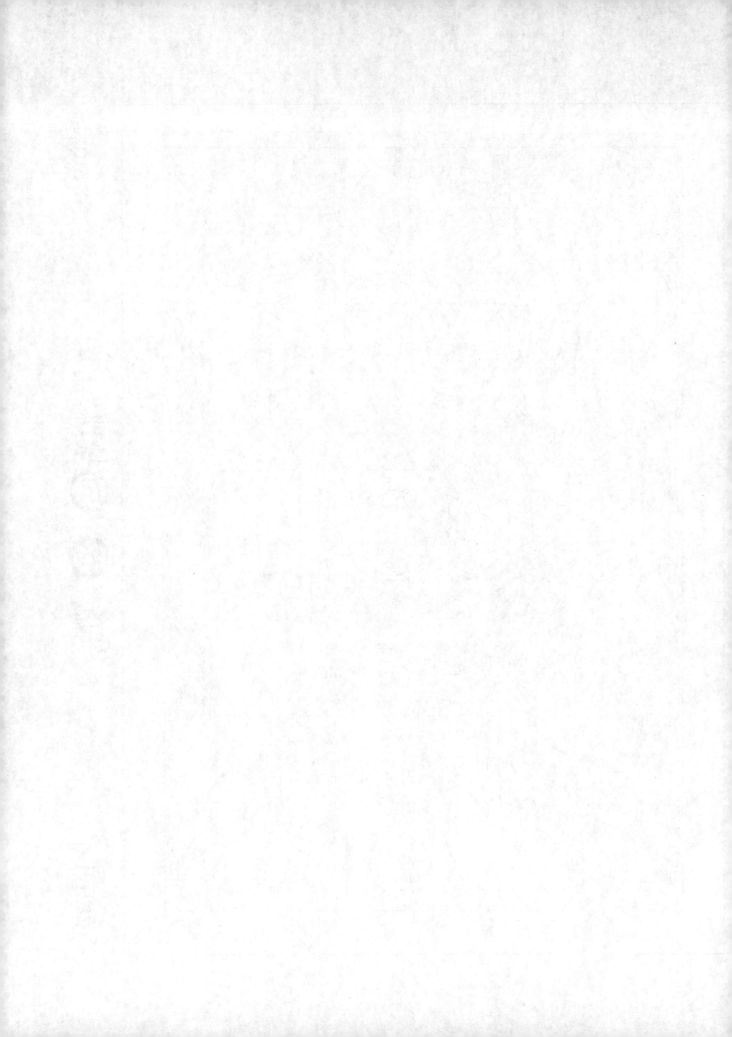

Creativity

Purpose ③ ⑧ Identity
Fate Destiny

Ambition

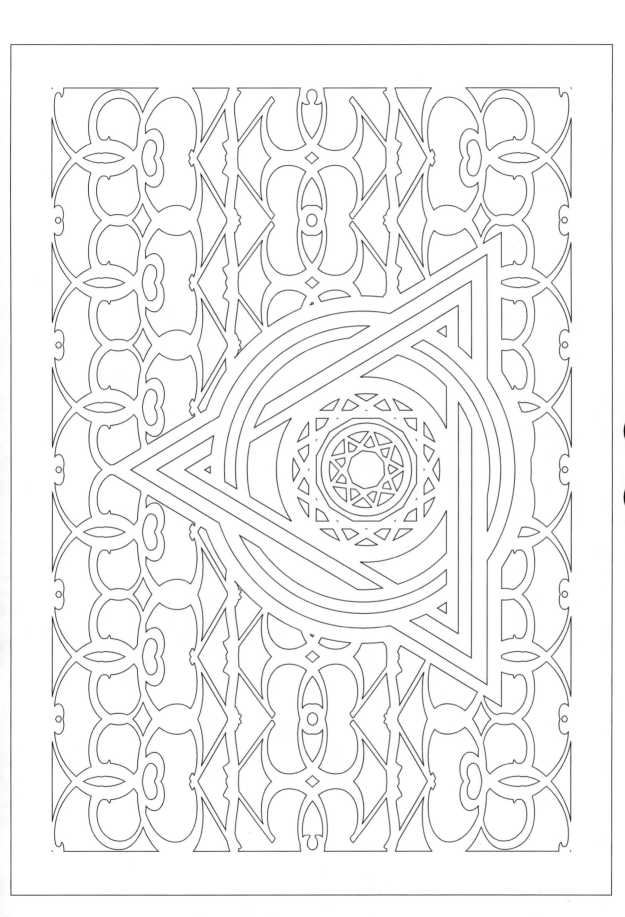

Creativity

Purpose ③ ⑨ Identity
Fate Destiny

Altruism

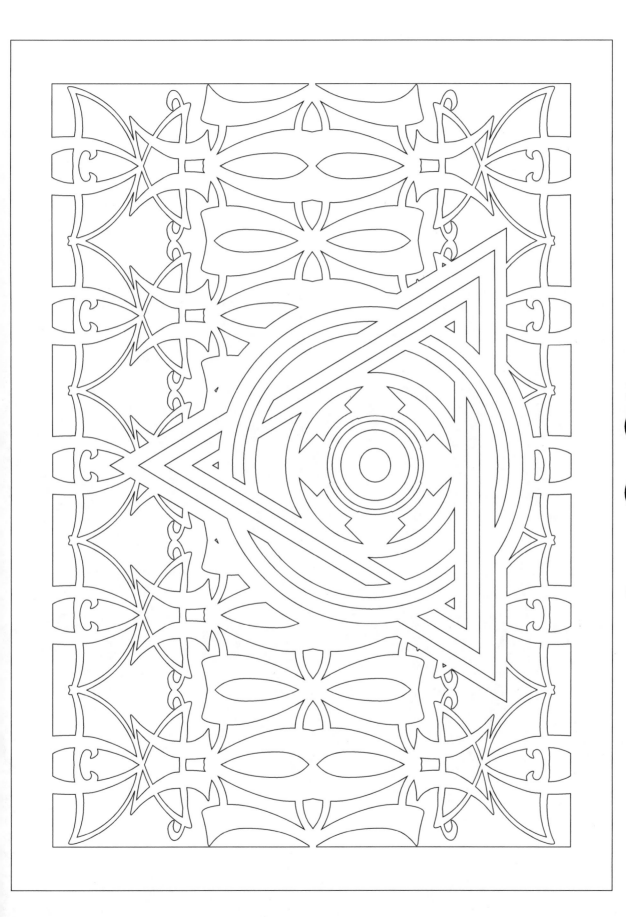

Initiation

Purpose **4** **1** Identity
Fate Destiny

Determination

Determination

Purpose ④ ② Identity
Fate Destiny

Partnerships

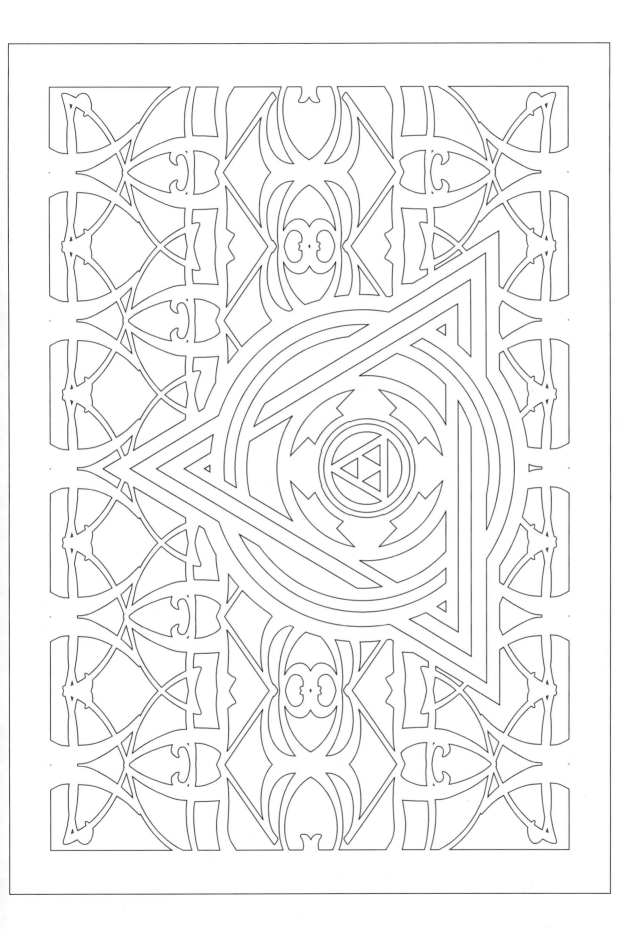

Determination

Creativity

Purpose ④ ③ Identity
Fate Destiny

Stability

Purpose **4** **4** Identity
Fate Destiny

Determination

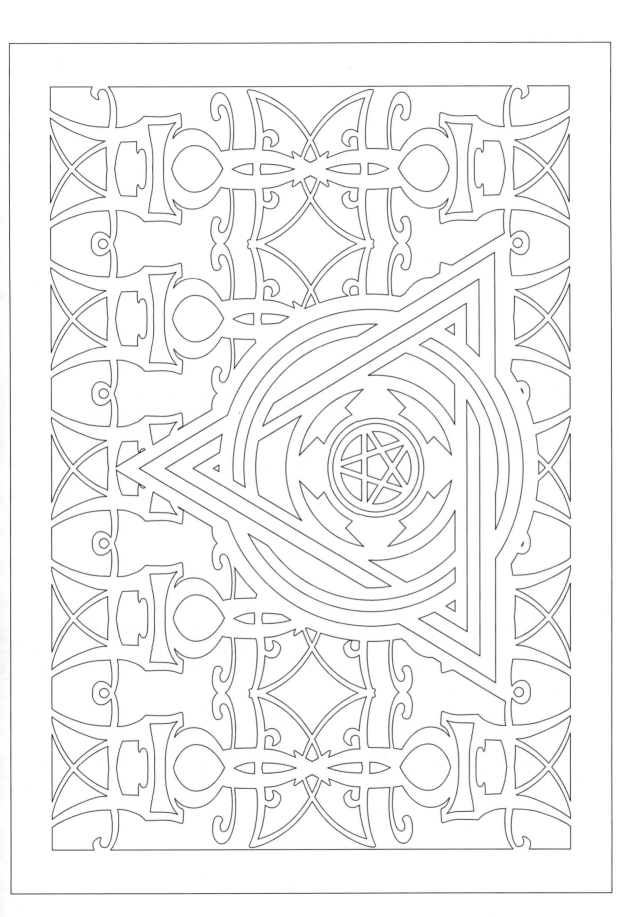

Determination

Purpose ④ ⑤ Identity
Fate Destiny

Adaptation

Obligation

Purpose 4 6 Identity
Fate Destiny

Determination

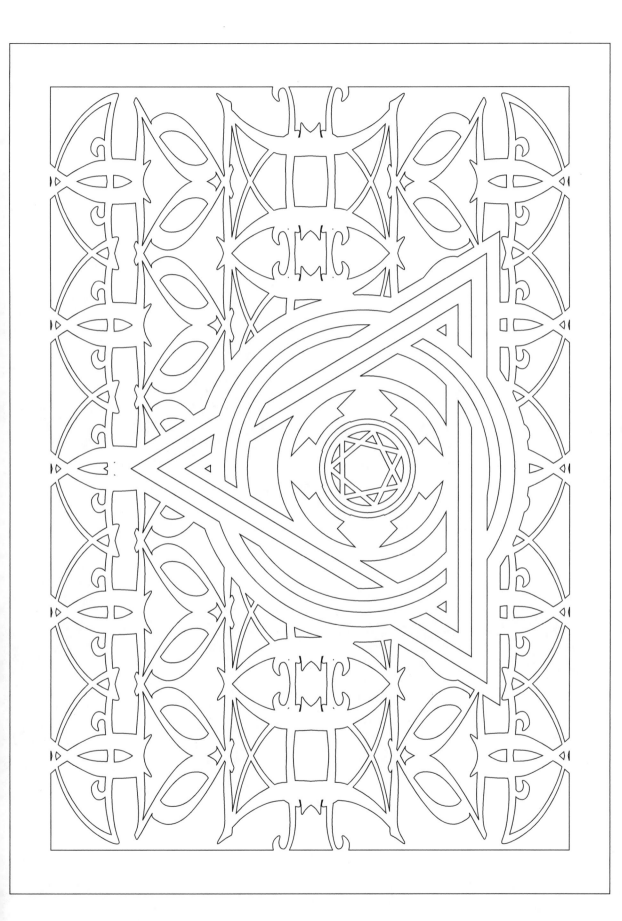

Determination

Purpose ④ ⑦ Identity
Fate Destiny

Analysis

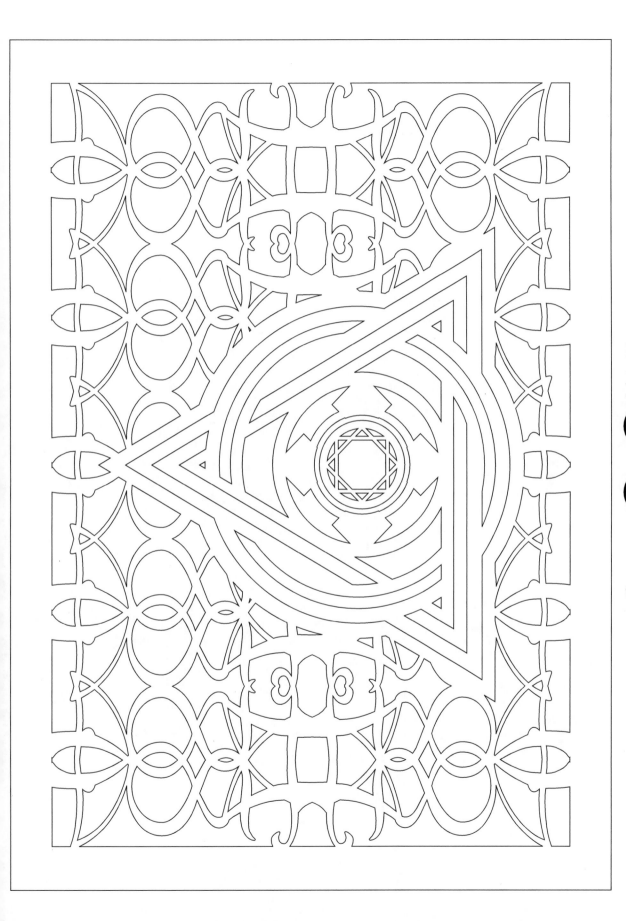

Determination

Purpose ④ ⑧ Identity
Fate Destiny

Ambition

Determination

Purpose **4** Fate

Identity **9** Destiny

Altruism

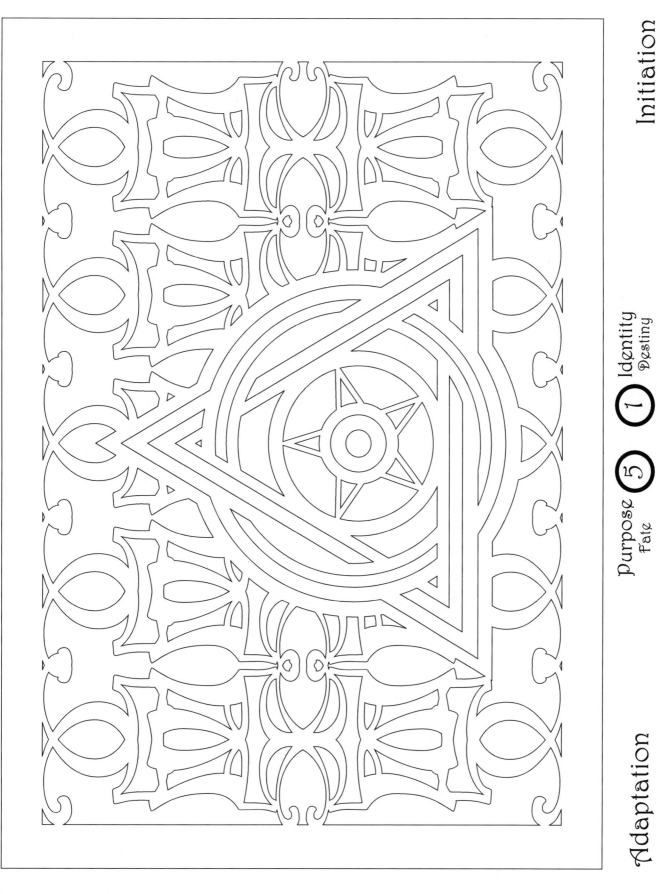

Initiation

Purpose ⑤ ① Identity
Fate Destiny

Adaptation

Partnerships

Identity
Destiny
②

Purpose
Fate
⑤

Adaptation

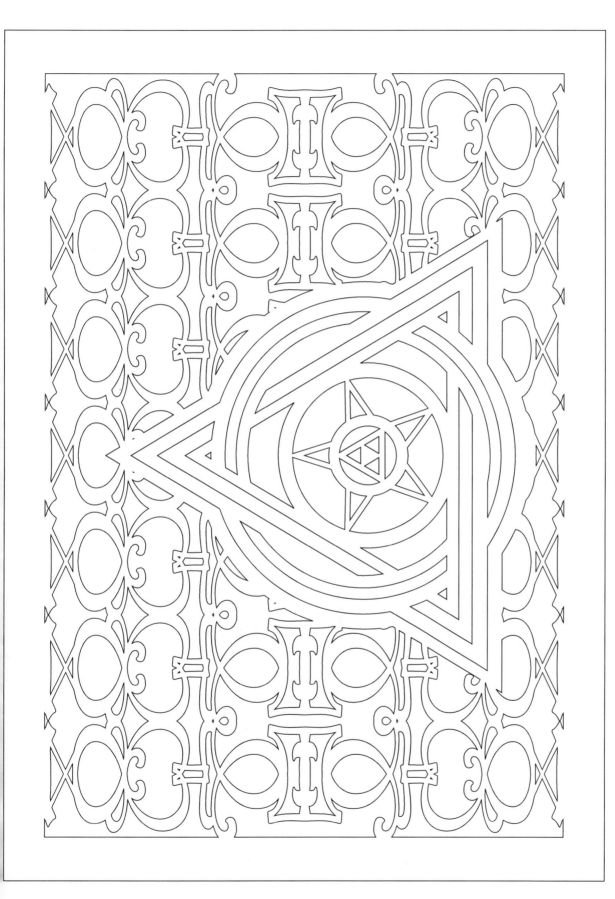

Adaptation

Purpose ⑤ ③ Identity
Fate Destiny

Creativity

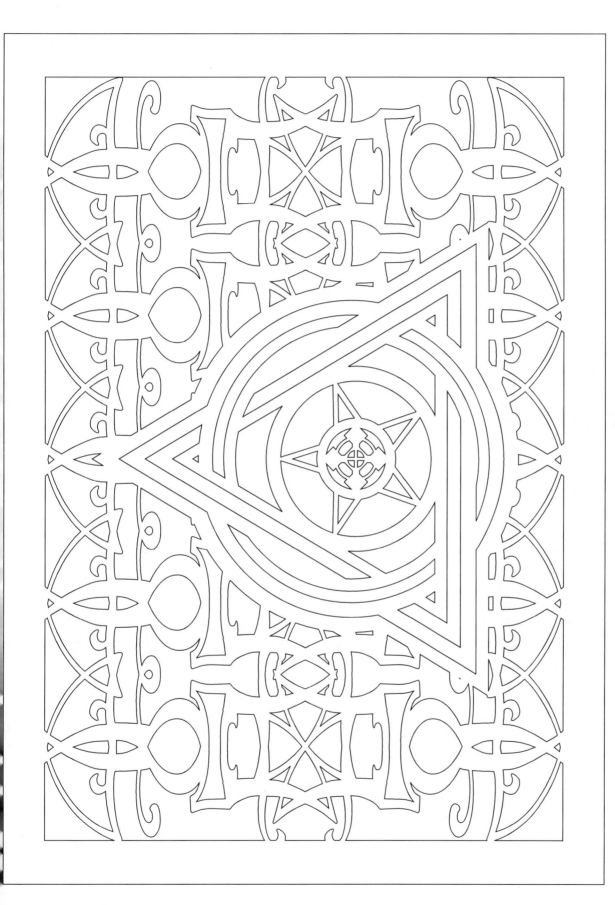

Adaptation

Purpose ⑤ ④ Identity
Fate Destiny

Stability

Adaptation

Purpose ⑤ ⑤ Identity
Fate Destiny

Curiosity

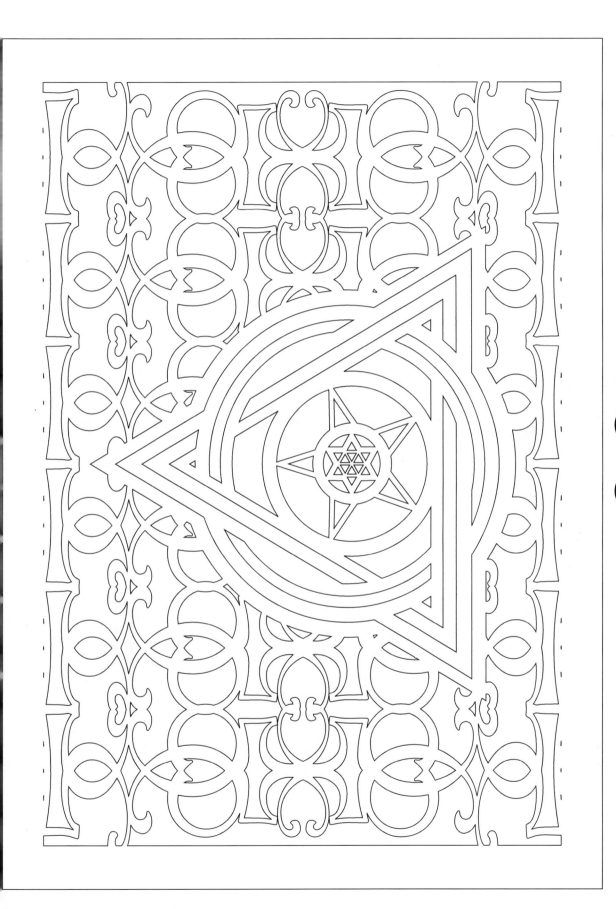

Adaptation

Purpose
Fate ⑤ ⑥ Identity
Destiny

Obligation

Adaptation

Purpose 5 Identity 7 Analysis
Fate Destiny

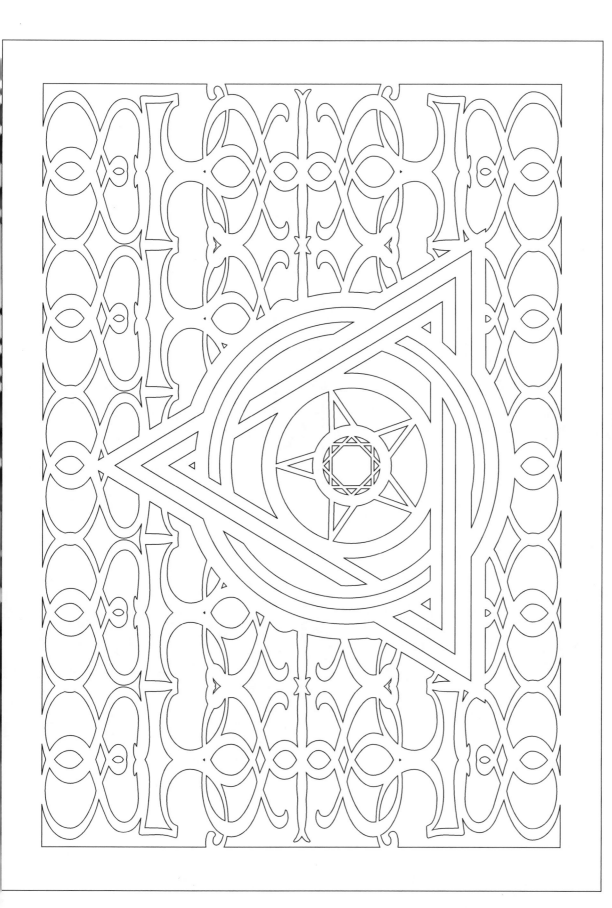

Adaptation

Purpose ⑤ ⑧ Identity
Fate Destiny

Ambition

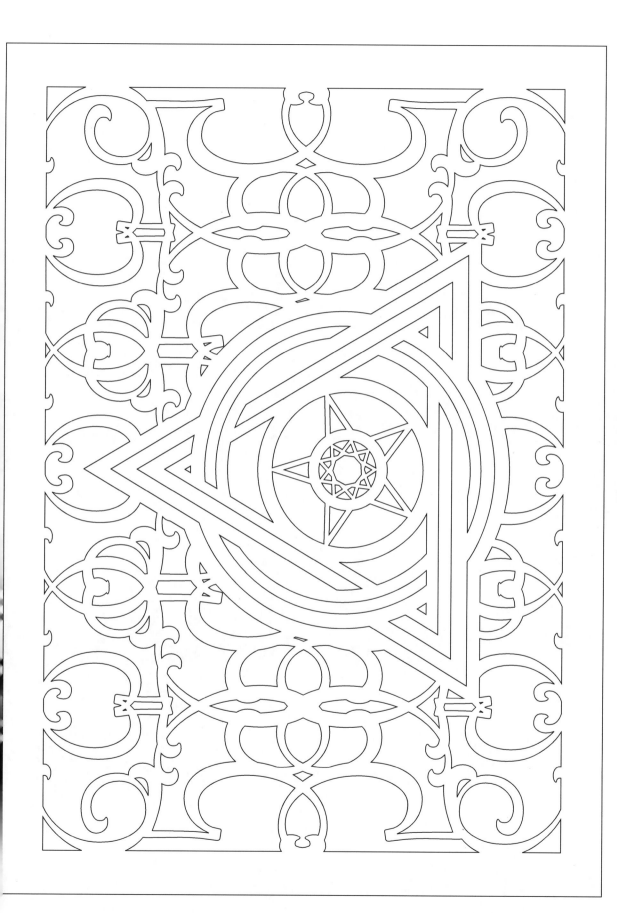

Altruism

Identity
Destiny

Purpose ⑤ ⑨ Fate

Adaptation

Identity
Destiny

Purpose 6 1

Fate

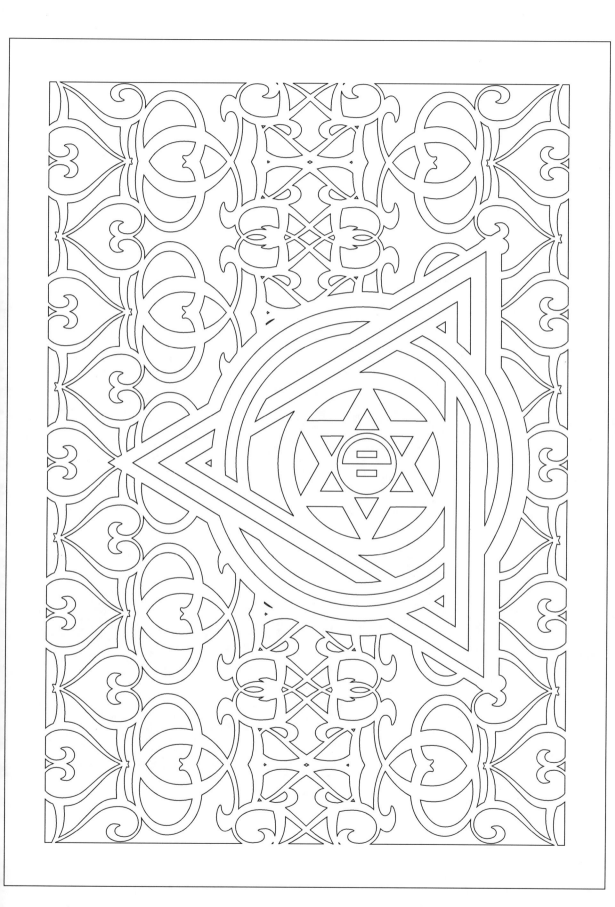

Obligation

Purpose **6**
Fate

2
Identity
Destiny

Partnerships

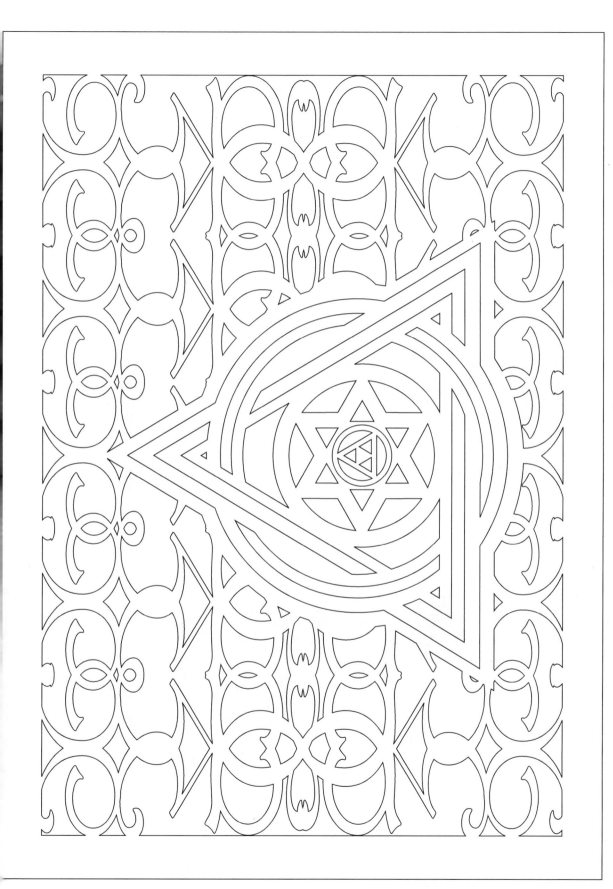

Creativity

Identity
Destiny

Purpose ⑥ ③

Fate

Obligation

Stability

Identity
Destiny

Purpose ⑥ ④
Fate

Obligation

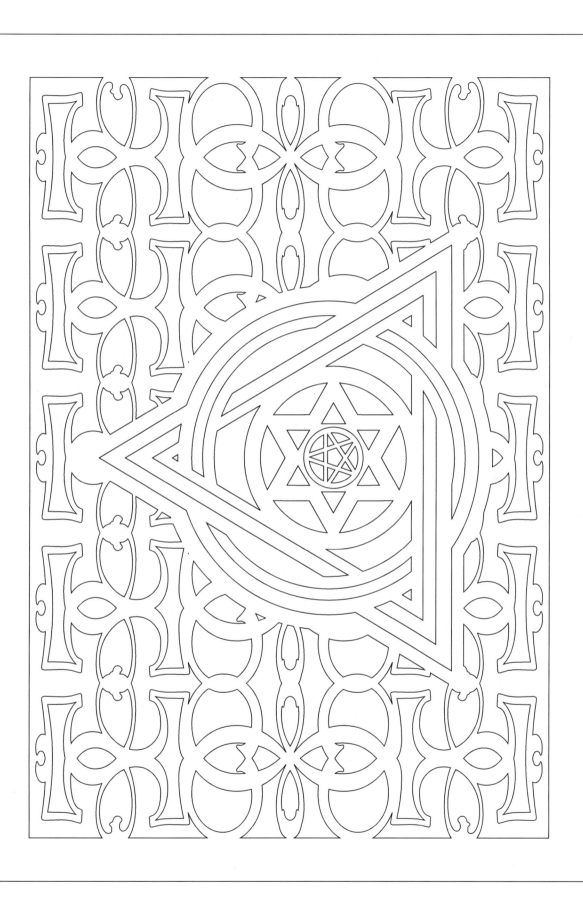

Obligation

Purpose ⑥ ⑤ Identity
Fate ⑤ Destiny

Adaptation

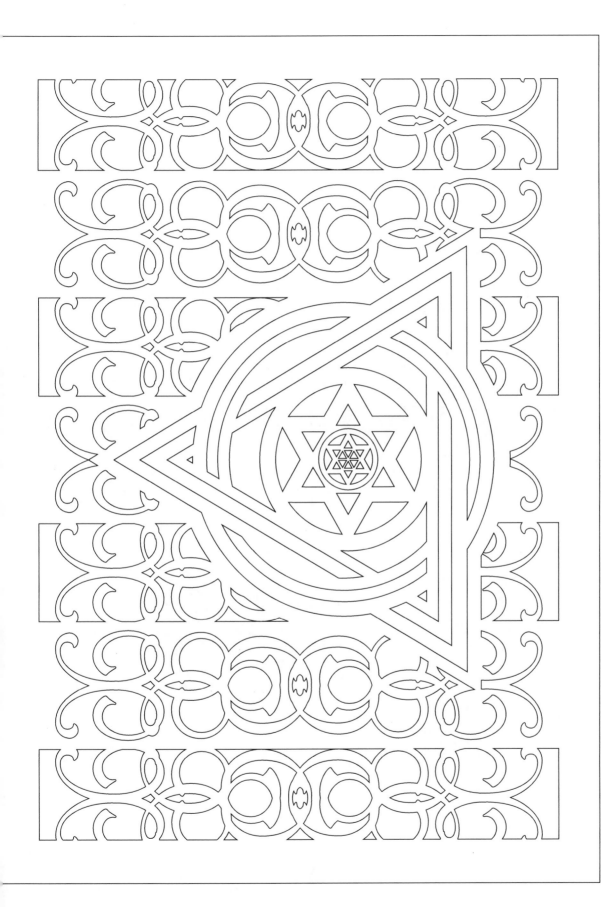

Loyalty

Identity
Destiny

Purpose
Fate

Obligation

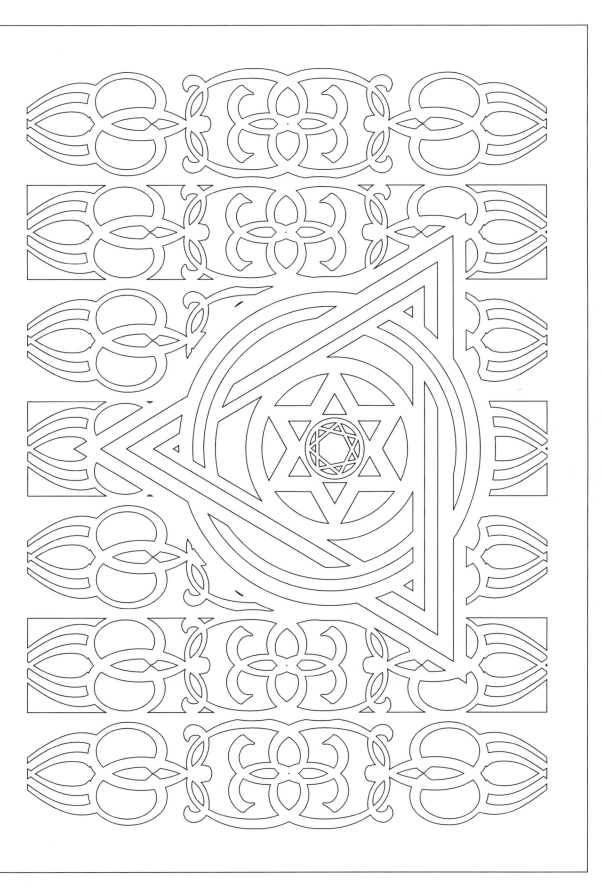

Obligation

Purpose ⑥

Identity
Destiny

⑦

Fate

Analysis

Obligation

Purpose ⑥ ⑧ Identity
Fate Destiny

Ambition

Obligation

Purpose 6 9 Identity
Fate Destiny

Altruism

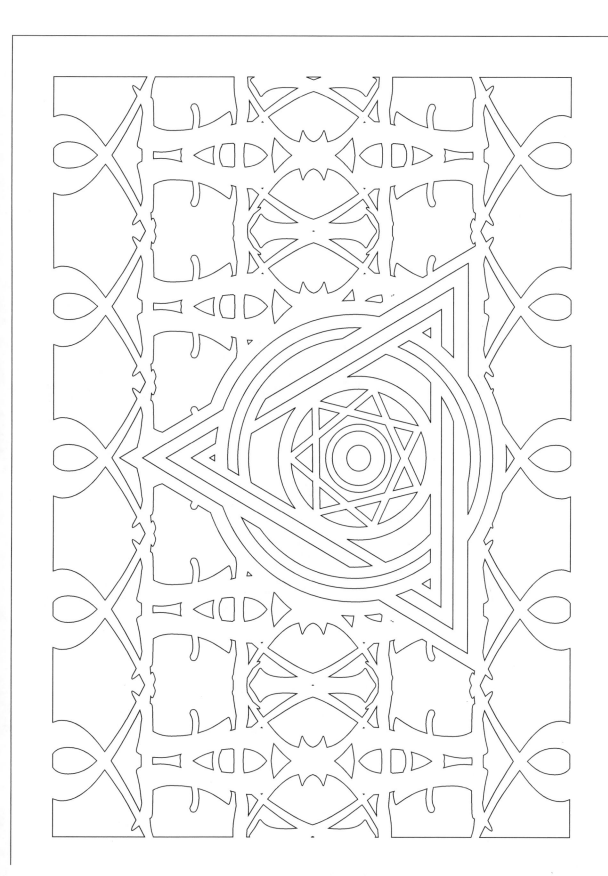

Initiation

Introspection

Identity
Destiny

Purpose 7 1
Fate

Introspection

Purpose ⑦ ② Identity
Fate Destiny

Partnerships

Creativity

Identity
Destiny

Purpose 7 3
Fate

Introspection

Introspection

Purpose ⑦
Fate

Identity ④
Destiny

Stability

Introspection

Purpose ⑦ ⑤ Identity
Fate Destiny

Adaptation

Introspection

Obligation

Purpose
Fate

7

Identity
Destiny

6

Introspection

Purpose **7** Identity **7** Analysis

Fate Destiny

Ambition

Purpose 7

Identity
Destiny

8 Fate

Introspection

Identity
Destiny

Purpose (7) (9)
Fate

Introspection

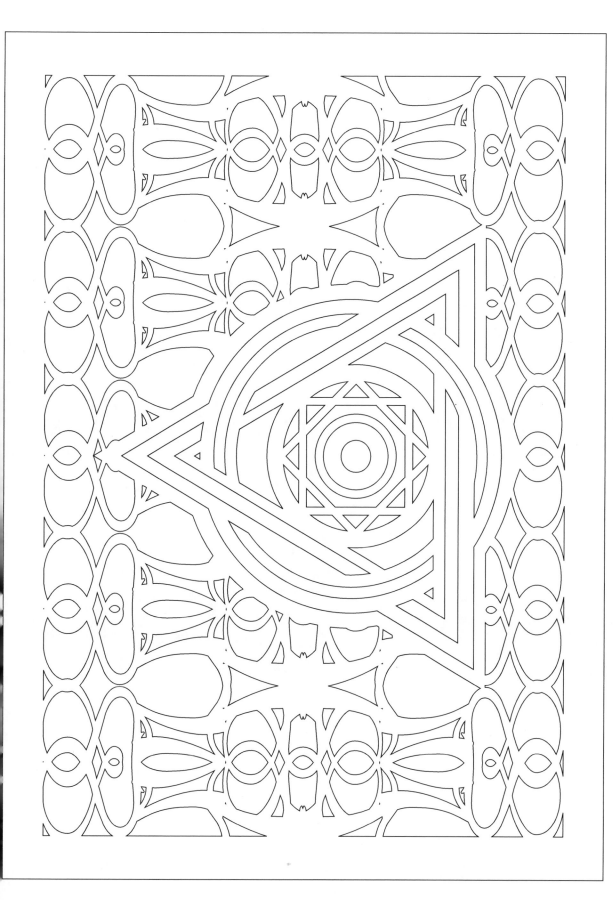

Identity
Destiny

Purpose 8 1

Fate

Authority

Purpose ⑧ ② Identity
Fate　　　Destiny

Partnerships

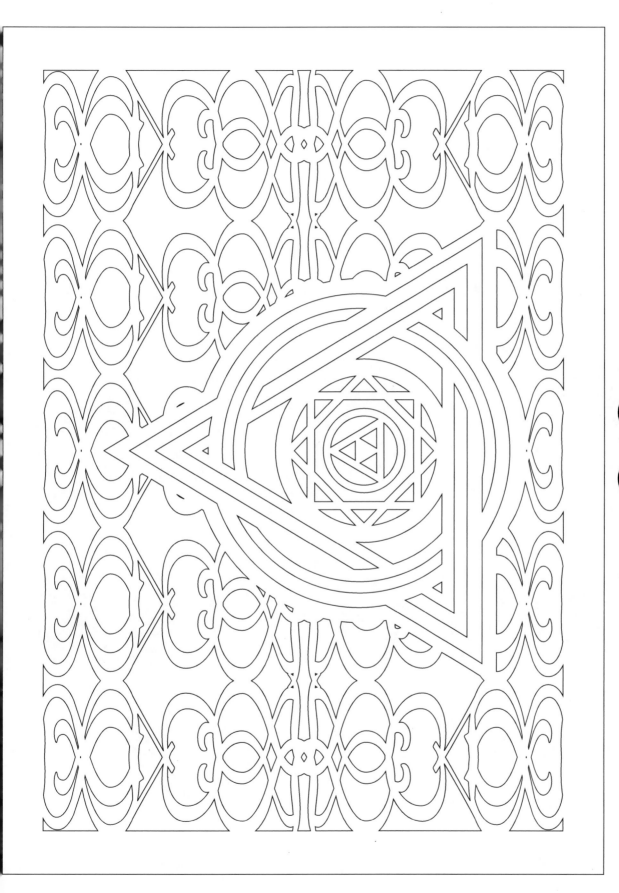

Creativity

Identity
Destiny

Purpose (8) (3)
Fate

Authority

Purpose ⑧ ④ Identity
Fate Destiny

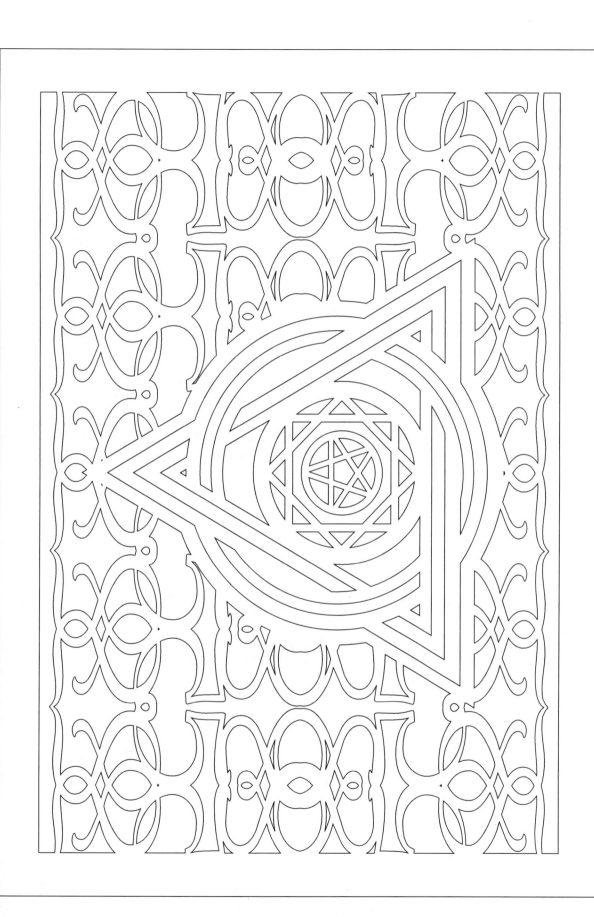

Authority

Purpose (8) (5) Identity
Fate Destiny

Adaptation

Authority

Purpose 8 6 Identity
Fate Destiny

Obligation

Authority

Analysis

Purpose ⑧ ⑦ Identity
Fate Destiny

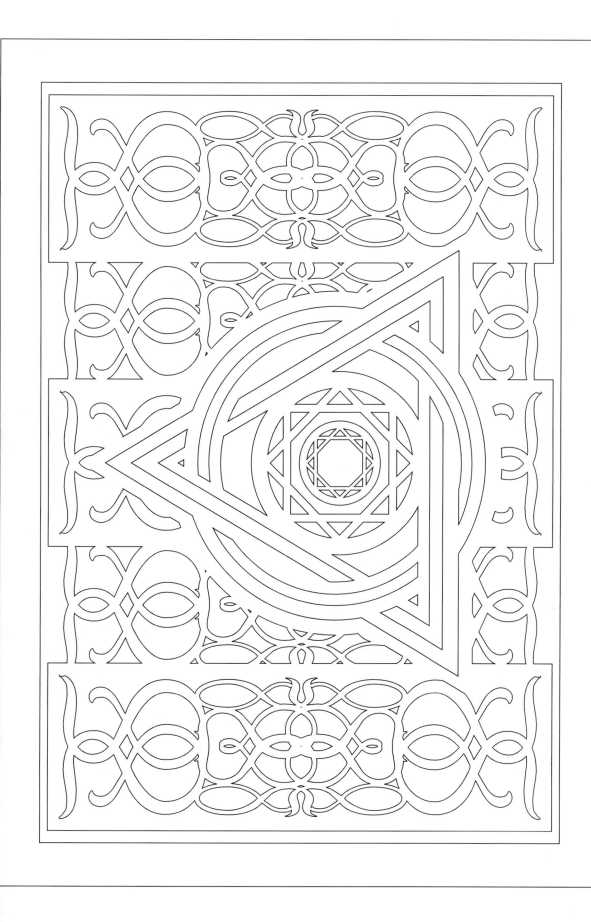

Authority

Purpose
Fate
(8)

(8)
Identity
Destiny

Ambition

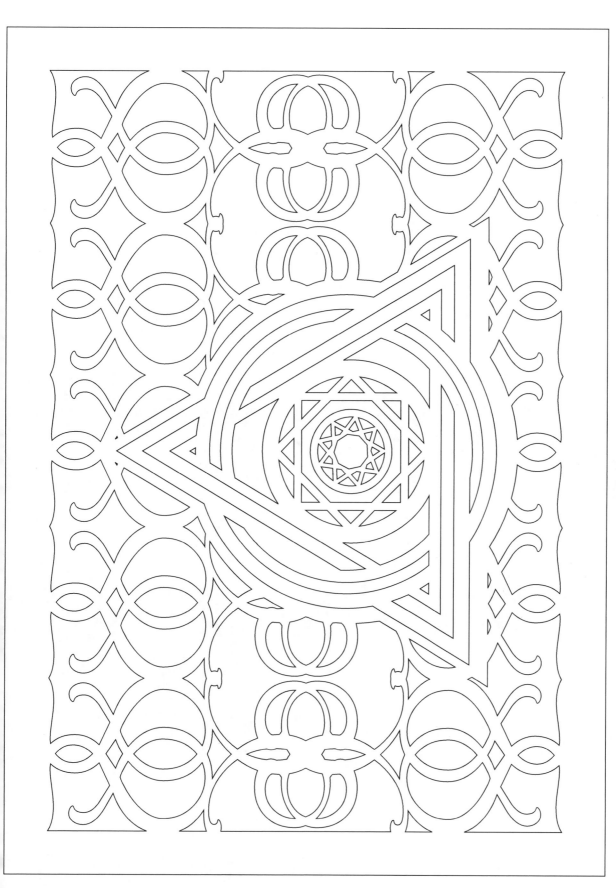

Authority

Purpose 8 9 Identity
Fate Destiny

Altruism

Initiation

Purpose ⑨ ① Identity
Fate Destiny

Release

Release

Purpose 9 2 Identity
Fate Destiny

Partnerships

Creativity

Identity
Destiny

Purpose ☽ ☉ ③

Fate

Release

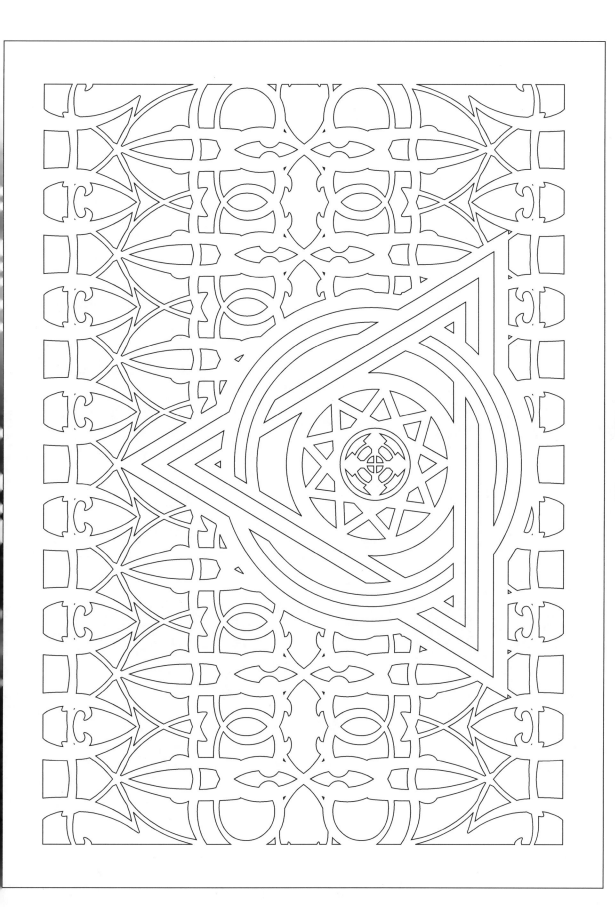

Release

Purpose ⑨ ④ Identity
Fate Destiny

Stability

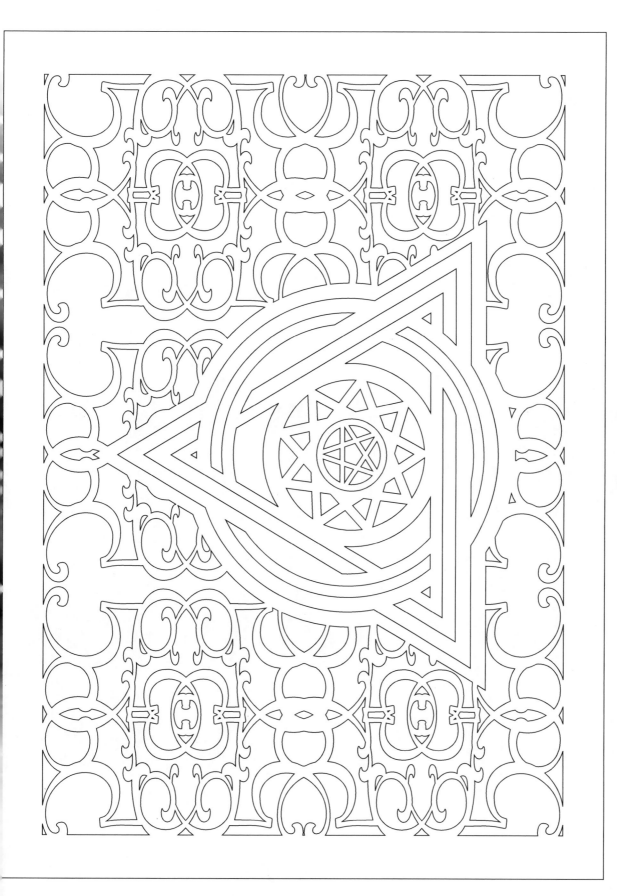

Release

Purpose
Fate

Identity
Destiny

Adaptation

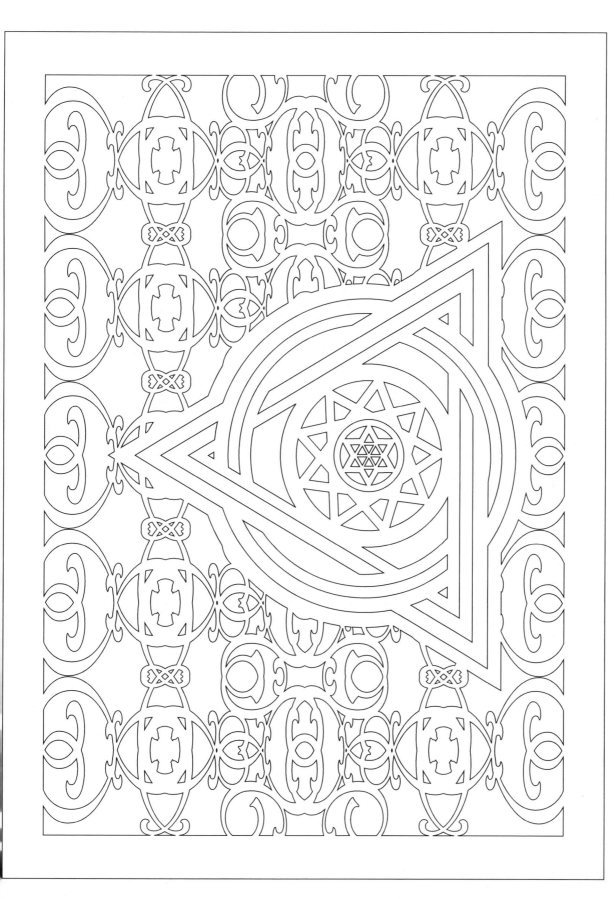

Release

Purpose
Fate

Identity
Destiny

Obligation

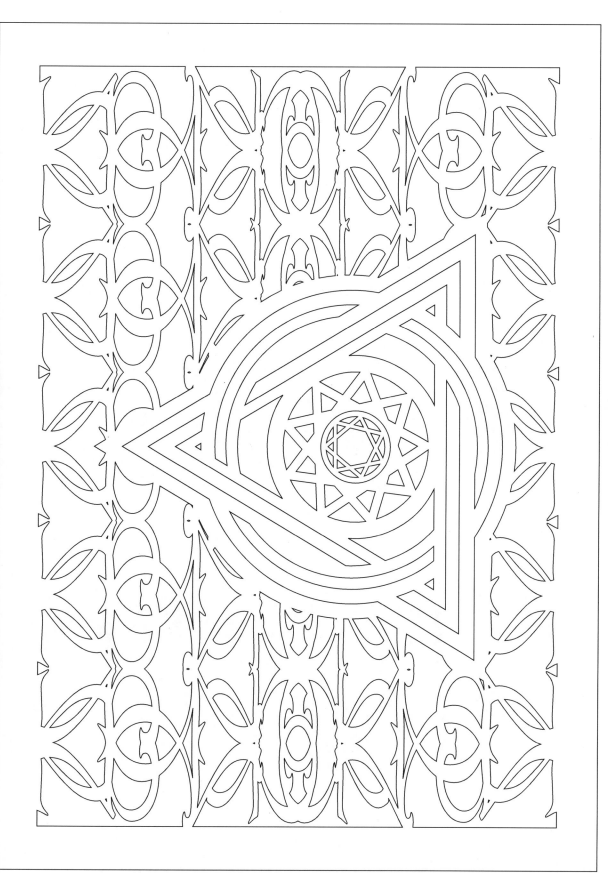

Release

Purpose ⑥ ⑦ Identity
Fate Destiny

Analysis

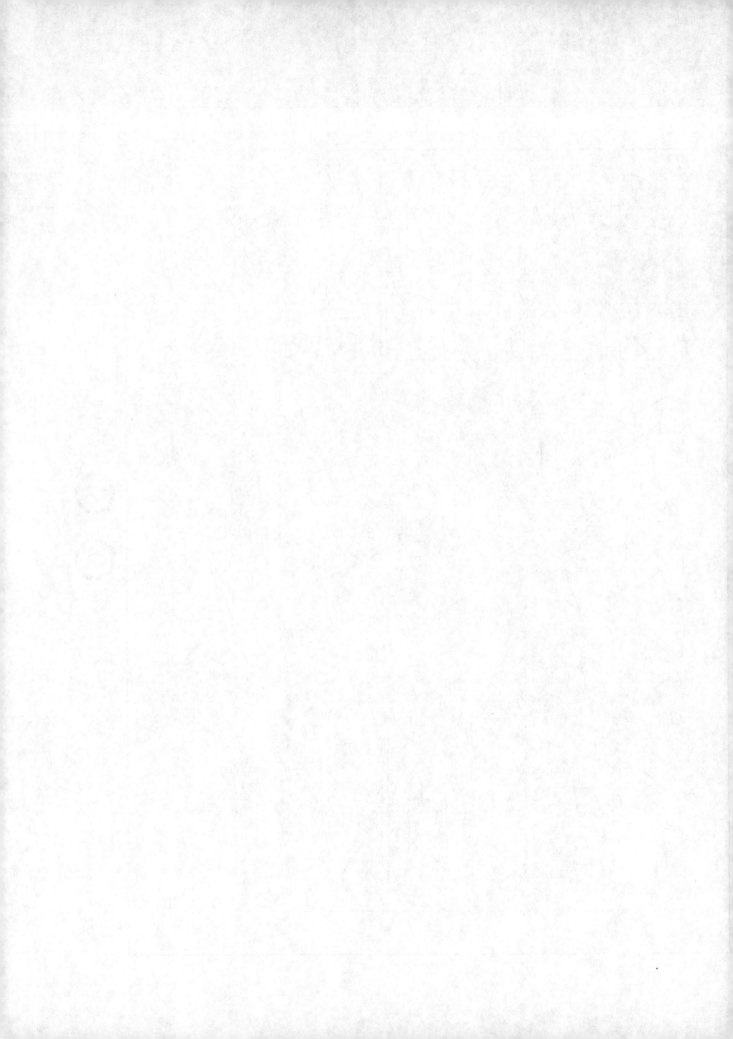

Ambition

Purpose ⑨ ⑧ Identity
Fate Destiny

Release

Release

Purpose ☉ ⊙ ⊙ Identity
Fate Destiny

Altruism

Notes

Notes

Notes

Printed in the United States
By Bookmasters